Eddie Peake
The Forever Loop

Barbican
Ridinghouse

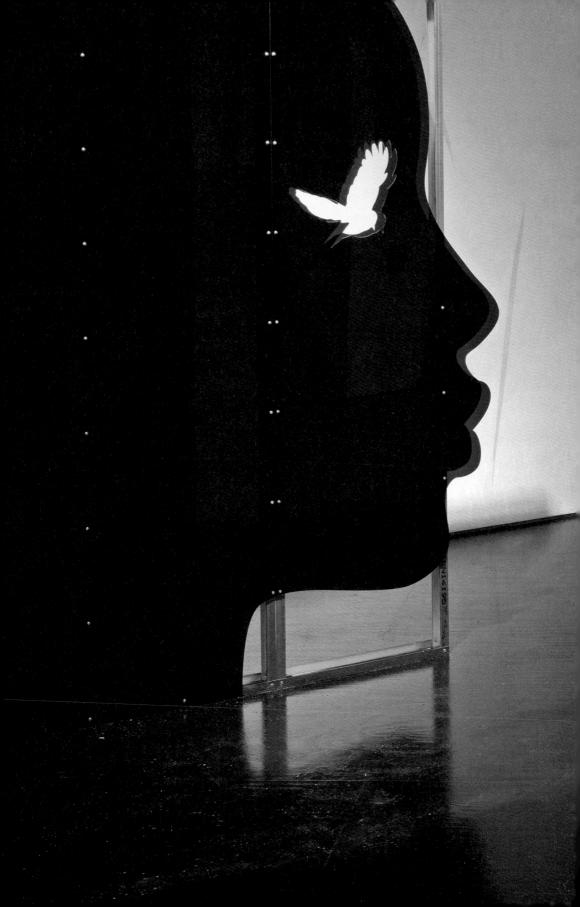

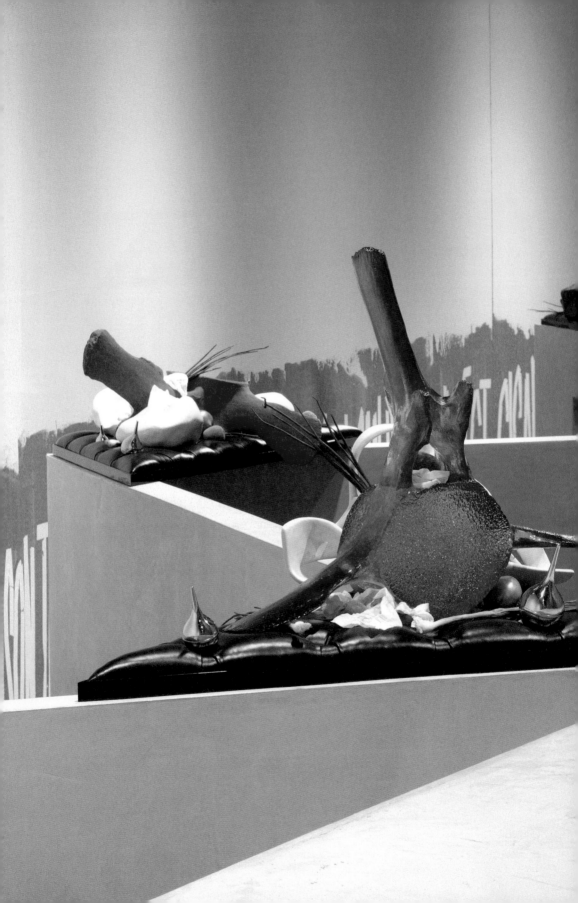

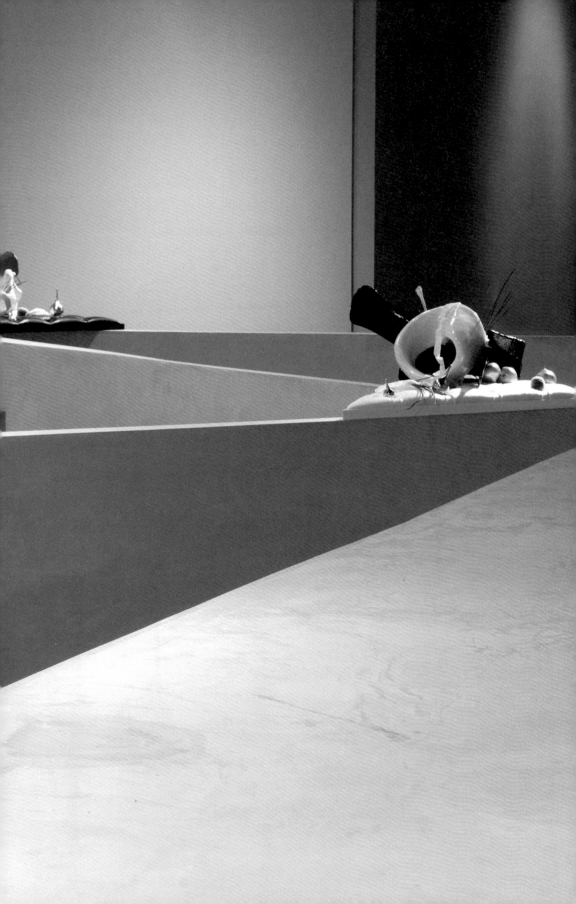

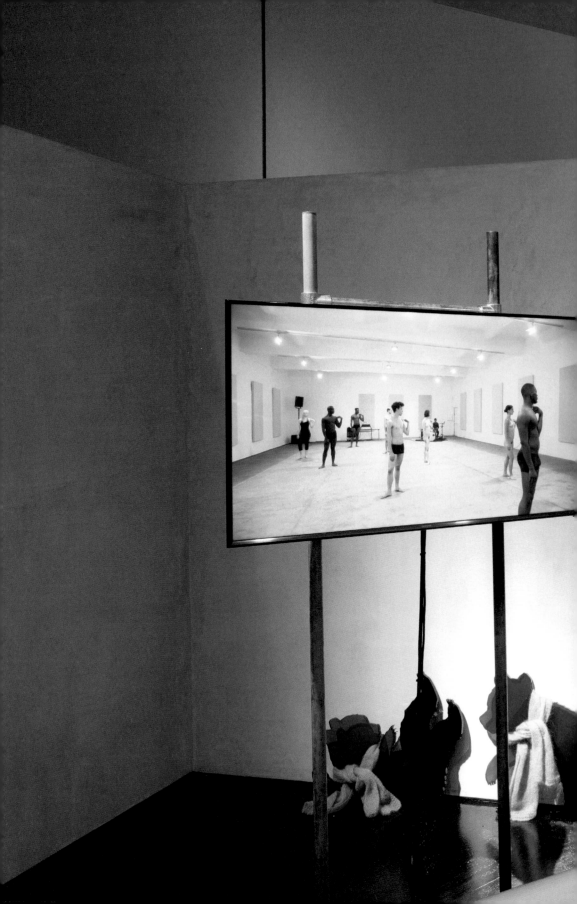

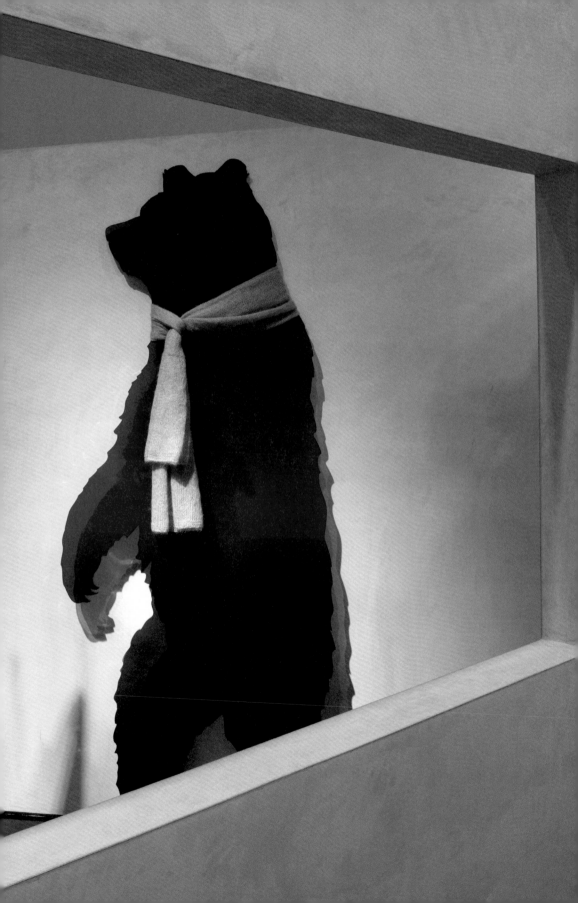

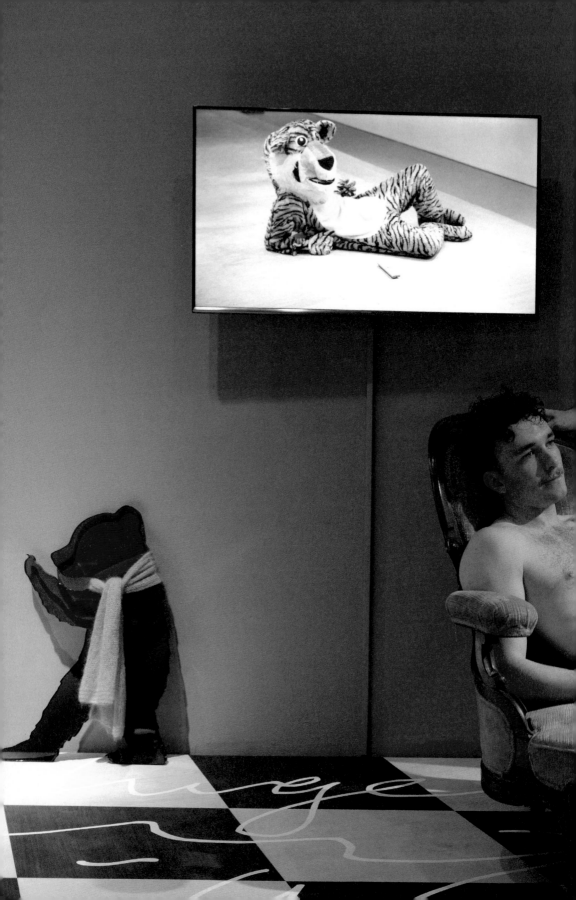

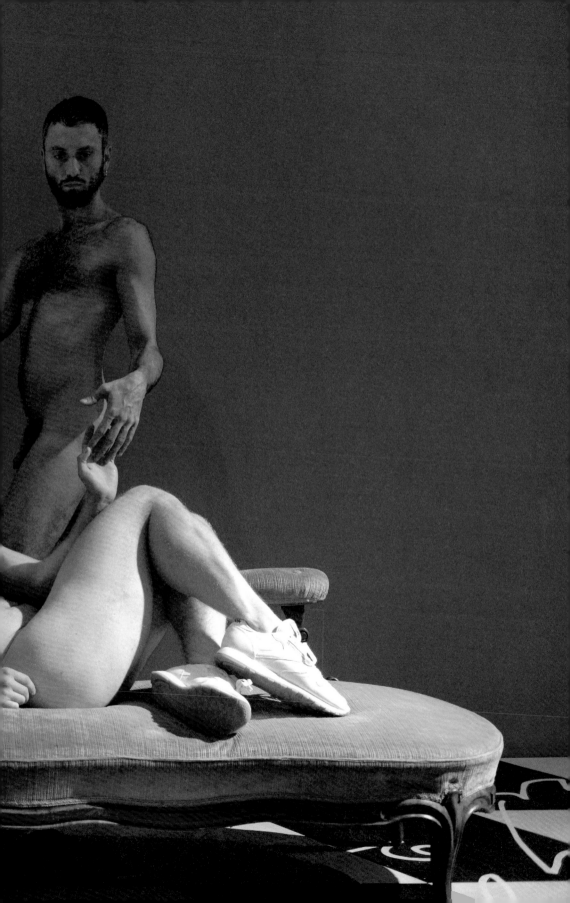

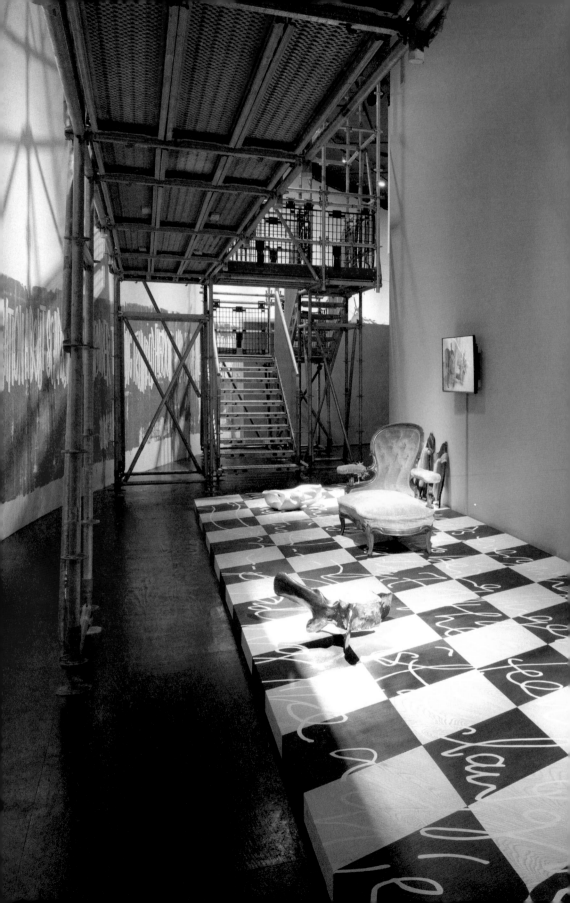

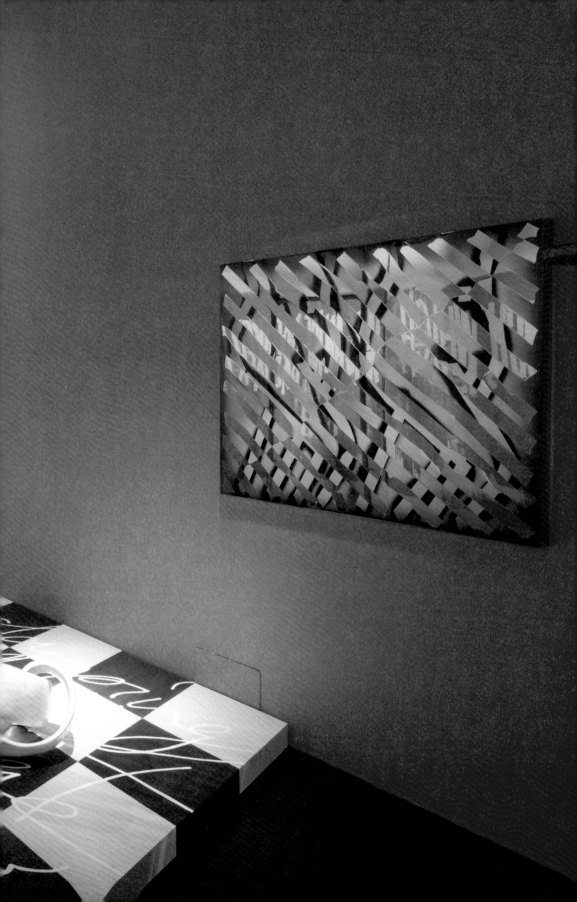

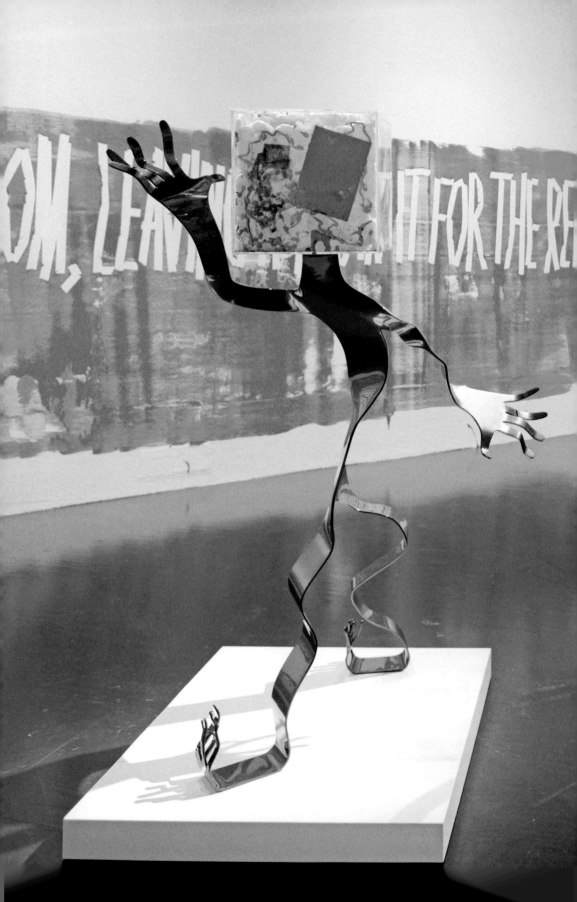

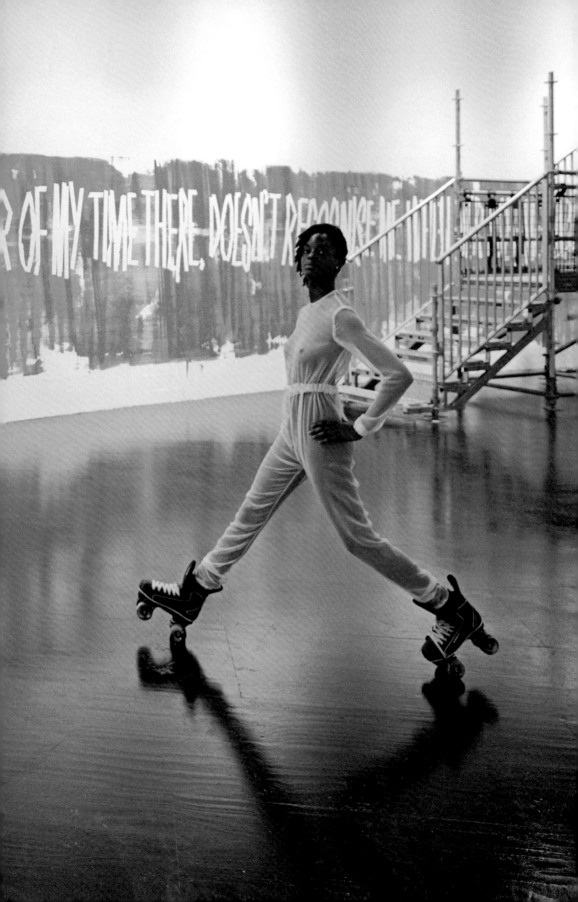

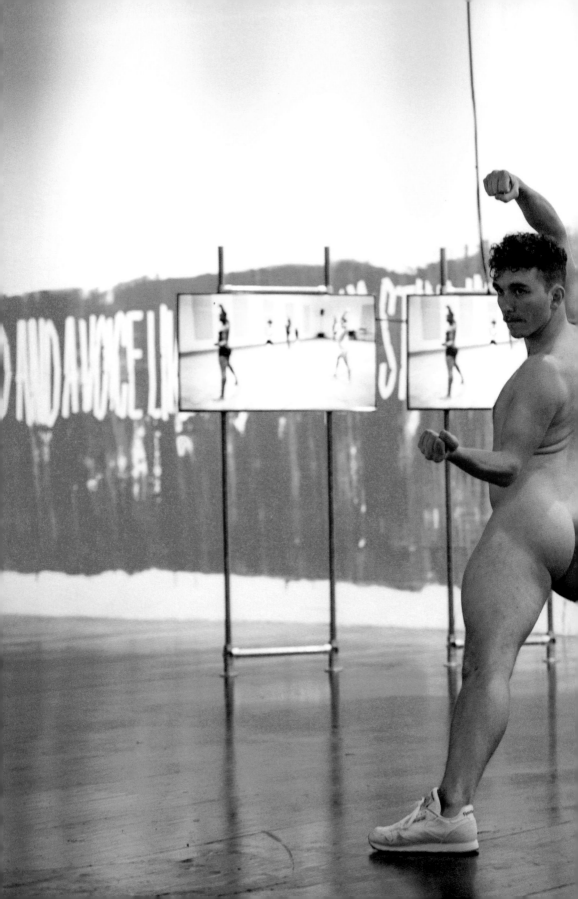

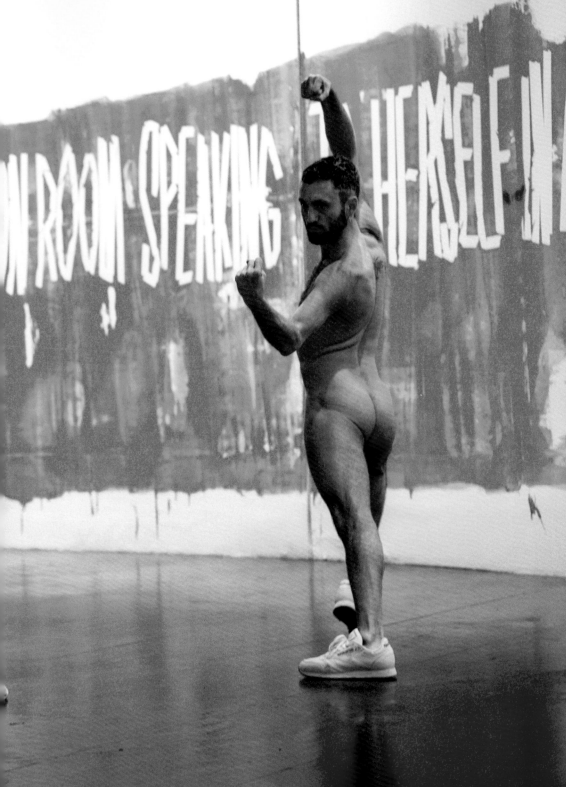

The Forever Loop
Omar Kholeif

I first encountered the work of Eddie Peake not in a gallery space, but in the underbelly of Dalston in a tiny club called Vogue Fabrics in 2012. Peake, along with fellow artists Prem Sahib – who was also studying at the Royal Academy Schools in London at the time – and George Henry Longly, had staged something that nebulously resembled a club night. Called Anal House Meltdown (now commonly known as AHMD), the event was a smorgasbord of sexual contradictions, where hot girls rubbed shoulders with boys and drag queens (now more commonplace on the London circuit). Sometimes, they would perform on a tiny stage amidst Peake and company's DJ sets. The event, which still continues throughout London (and occasionally on the global stage), now also regularly includes a range of happenings, from book launches to art installations. Whatever the proclivities of the performers and clientele, AHMD has always been decidedly queer in its attempt to blur not only the boundaries of sexuality, but also that of hi- and lo-brow culture. The impetus behind such an endeavour was not simply political posturing, but a desire to explode the binary realms that have so often divided the populist tactics of the artistic milieu.

The celebratory politics underpinning this event also informed the second project of Peake's that I was to experience, when the infamous pirate radio station Kool London took over Burlington Gardens during the artist's Royal Academy degree show in 2013. Here, Kool's affiliated members – MC Det, Funky Flirt, Brockie and Eastman – brought a subculture of bootlegging into one of Britain's most traditional art spaces. Analogue audio bootlegging is a practice that is now scarce, having been replaced by an era of the click-happy digital downloads. Here, it was made public as a living monument to an era past – as well as to the numerous communities – that have been overtaken by internet radio.

These two encounters emerged after a series of undertakings in which the artist had critically deconstructed a set of very specific visual iconographies. The most notorious of these was

a choreographed five-a-side football match, where the players were naked except for their coloured socks, which indicated their teams. The piece, *Touch* (2012), was less a straightforwardly erotic exercise and more an attempt to examine how statuesque bodies – that may otherwise seem like dormant containers – can be animated through play. The artist has called the body 'an ambiguous aesthetic space', and the figures in this performance became evermore confounding because of the variety of forms that they represented.[1] These were not the footballers that grace the pages of magazines in designer clothes or who surreptitiously flash their eight-packs, but rather, they were simply run-of-the-mill figures. One can argue that *Touch* was a catalytic call for the nude everyman: something that has been celebrated in queer subculture, often in the pages of zines such as *BUTT* or *meat* or discussed by the likes of fashion designer Tom Ford.

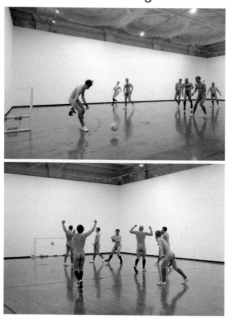

The prickly issues around gender relations were examined by Peake in the large-scale performances that were soon to follow: *Amidst A Sea Of Flailing High Heels And Cooking Utensils, part I* and *II* (both 2012; pp.24–25) and *Endymion* (2013; pp.28–29). In both bodies of work, Peake played with spectators' voyeuristic desires by presenting audiences with an array of male and female nudes covered in carefully placed glitter. In *Endymion*, which was staged by Performa in New York, these bodies were coated in both gold and black shimmer as they wandered out into the spaces of the Swiss Institute, rubbing up

close to the audience so as to puncture the fourth wall. Here, the gender of the bodies was only discernible via close examination of genitalia; the androgynous experience made this viewer flip between pangs of desire and discomfort in a matter of seconds. Accompanying this highly choreographed exchange of dancing bodies resembling Mystique from Marvel Comics's X-Men series was a live soundtrack that was at times epic and monumental, ebbing into silence before erupting once again into thumping, dramatic bursts. This project, like all of Peake's performative works so far, was devised during a rehearsal with invited dancers and musicians. Interestingly, unlike choreographers such as Michael Clark or Anne Teresa De Keersmaeker, Peake does not choreograph the movement of his dancers to music but, rather, layers the sound throughout the rehearsal process. He describes this as one of ongoing negotiation, where 'orthodoxy' is constant-ly being 'disrupted' and subsequently re-examined.

With all of this, I have yet to scratch the surfaces of Peake's prolific output. A truly twenty-first-century multi-hyphenate, in 2014 he teamed up with The Vinyl Factory to launch a record label called HYMN, whose first release was Gwilym Gold's heartbreak-ing single 'Muscle'. The ballad emerged from Gold's contribution to a gallery performance by Peake titled Infinite Disparity (2013; pp.26–27) the preceding year. HYMN's aim was to take on a single project at a time, with Peake acting as the mastermind that oversees everything – from record-sleeve design to music-video production – in order to create unique 'worlds' around each partic-ular element. The collaboration with Gold continued in his follow-ing release, 'Flex' (2015), which saw the artist directing a 3D animated video where bendy metallic characters with square light boxes for heads perform their vulnerability, bleeding desolately into each other's forms. A sex scene ensues, but the phallus they share appears to be an audio jack. These characters are not newly invented for this video but are recurring motifs that often appear in the artist's broad spectrum of interrelated projects. For exam-ple, a similar figure appears in a large-scale sculpture of painted steel and foam entitled Squalo Jpeg (2015; p.14). Such repetition, or rather the cyclical loop, is a key treatment – dancers, actors and figures in particular projects will reappear in different works, such as the naked roller skater who lounged around Peake's exhibition Adjective Machine Gun at White Cube, London, in 2013, and who resurfaces in the present Curve commission at the Barbican.

21

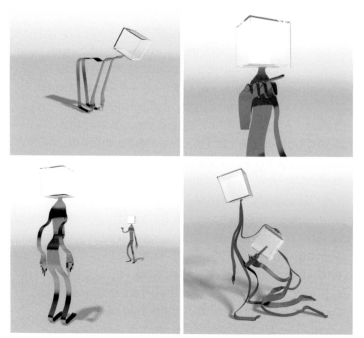

The loop has preoccupied artists for generations – from Chris Marker to Christian Marclay to Cory Arcangel, Judith Barry and Lynn Hershman Leeson – and in the twenty-first century has become the dominant mode, not only of cultural discourse but also of daily life. The democratisation of communication technologies means that 'search' has become a looping verb: 'googling' is a circuitous daily act, if not an hourly occurrence. Looping takes place on Spotify, on iPhones or on train lines. In fact, most current pop music is created not with live instruments, but from pre-formed, off-the-shelf segments of music also known as loops. As such, the loop is a process (a noun and a verb) that is pervasive in all forms of culture.

The language that informs these multifarious processes is scrutinised in the artist's paintings. Peake has now become known for his caustic coloured spray paintings bearing slogans such as 'Bad 2 Da', 'Badda Bada Bone' and 'Eddie Freak', which are often created using masking tape that is removed after painting to reveal a polished steel veneer. These surfaces function as reflective devices in the scenography for Peake's characters – a place where his sculptures, videos, dancers and actors will continue to be reflected in looping perpetuity. His approach to creating these objects is informed both by the conversations that they create as scenography and by their physicality. 'How

can I make a sculpture feel like an event?' he asks. This is something that can be seen in the work *No Brains* (2011), in which a black-and-white photograph depicts Peake lying naked on a balance ball; an image that is but a fragment of the artwork that also includes three canvases. Collectively, they create a three-dimensional material presence that supersedes the limits of medium specificity.

The journey into *The Forever Loop* is equally majestic in its bold attempt to eschew categorisation. Peake explains that he will be using the Curve's unique shape as a means to think of an expanded narrative: 'the exhibition will be like a sentence that you can never read at once'; the visitors must engage with the loop piecemeal before they can read it all. Perhaps this fragmentary approach is indicative of Peake's exacting tendency that places the desire for the singular phenomenological experience over the aspiration to examine the master narrative. This desire is part of a broader examination in the artist's work, one that sees him thinking about the body as both a sculpture and sexual object, amorphous in its nature – it becomes a conduit for the banal as well as the mystical and the sublime; a site that embodies all of our human insecurities. When put into motion its wanting movement reveals vulnerabilities and sincerities that otherwise would have remained forever unturned.

1 All quotations by Eddie Peake are drawn from conversations with the author, August 2015.

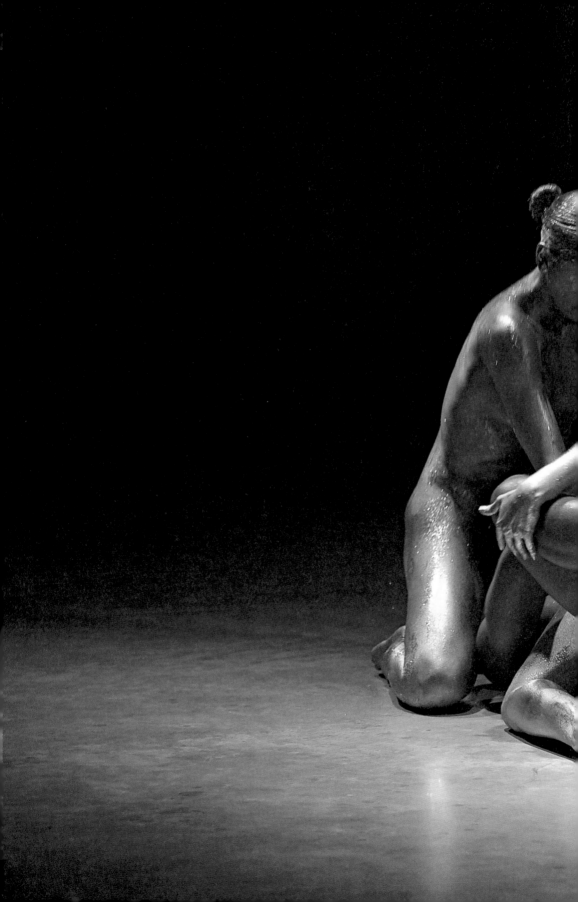

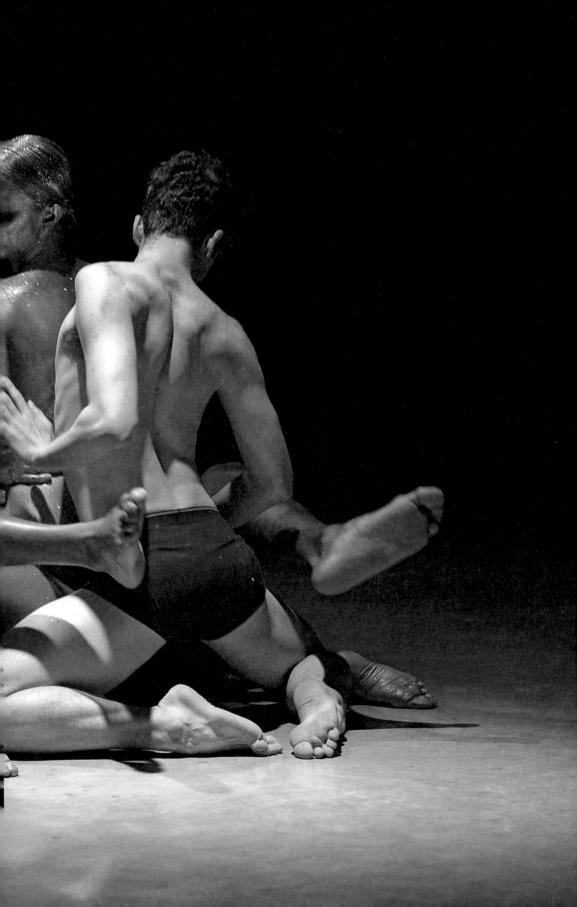

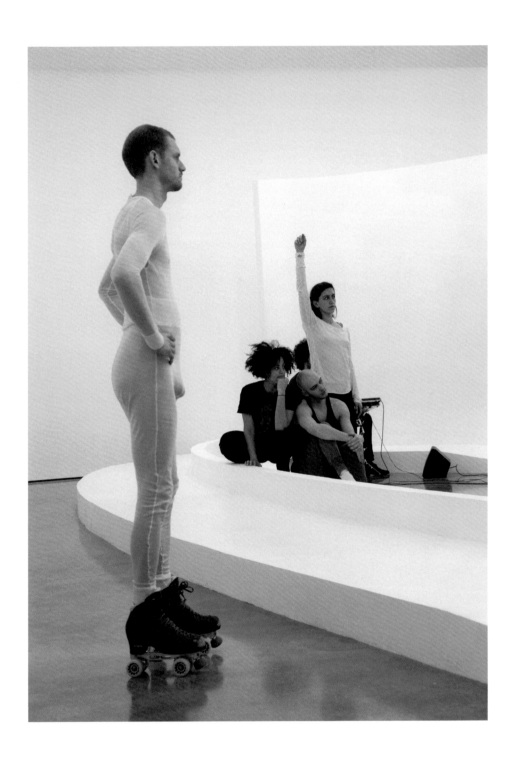

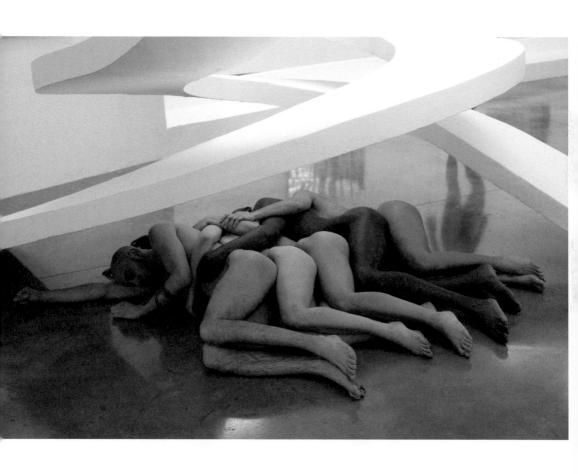

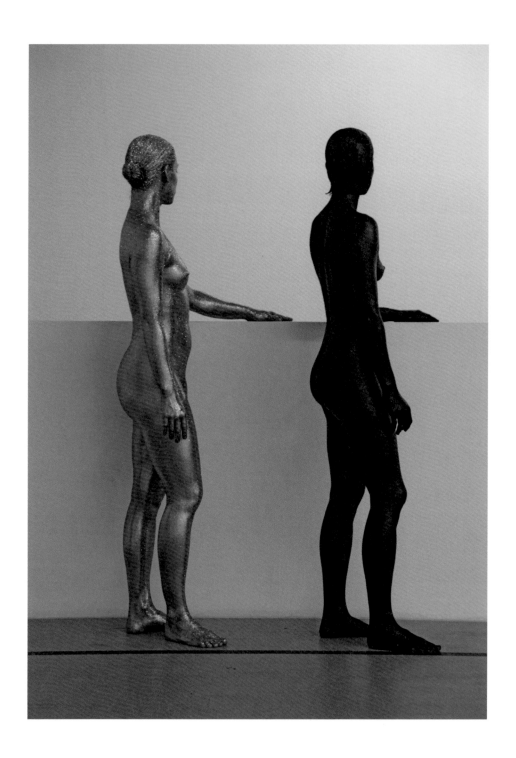

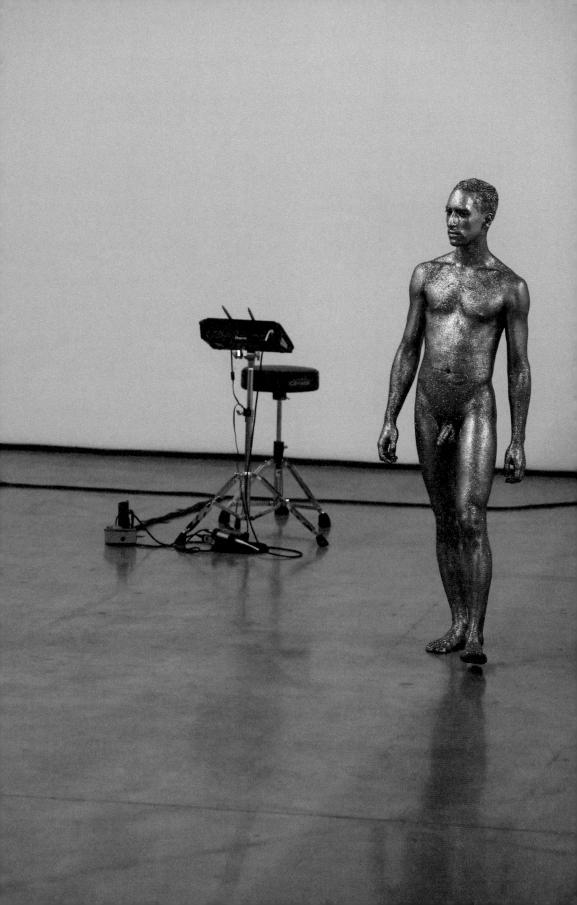

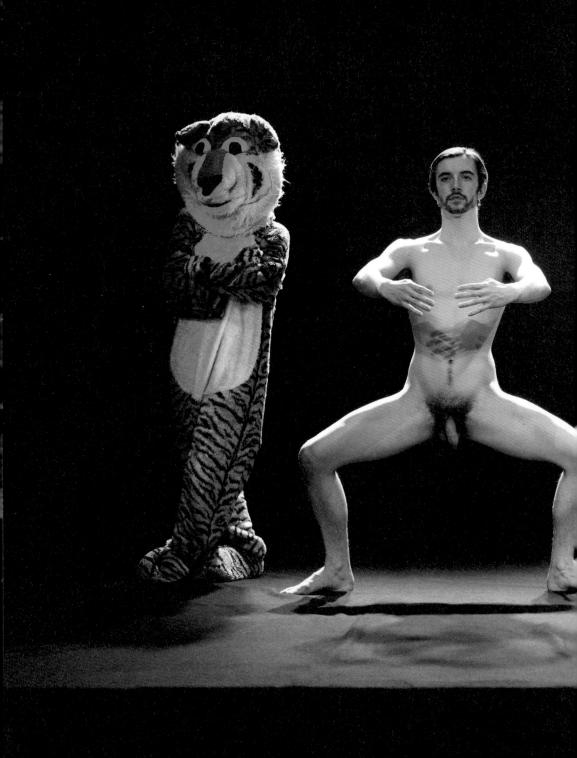

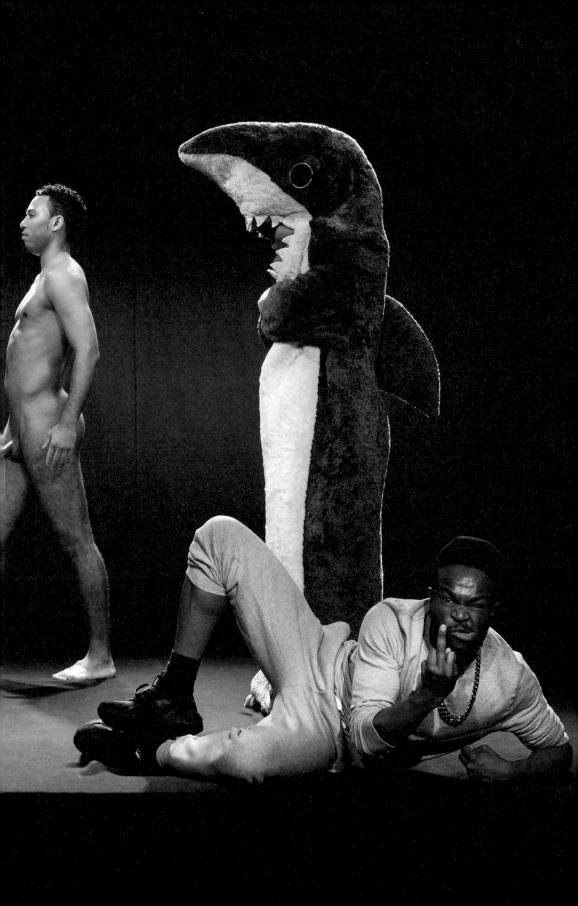

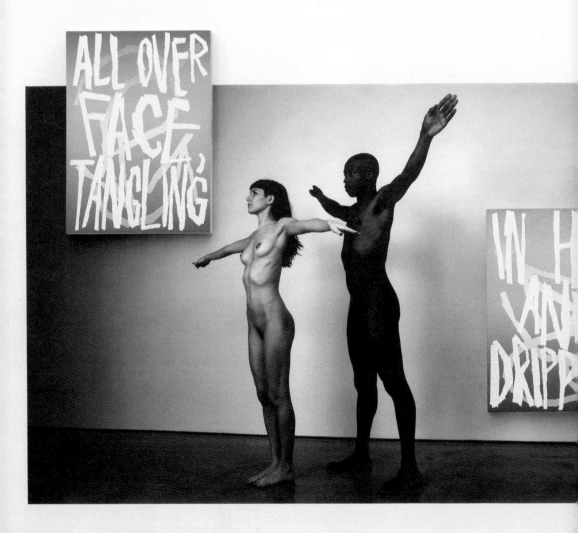

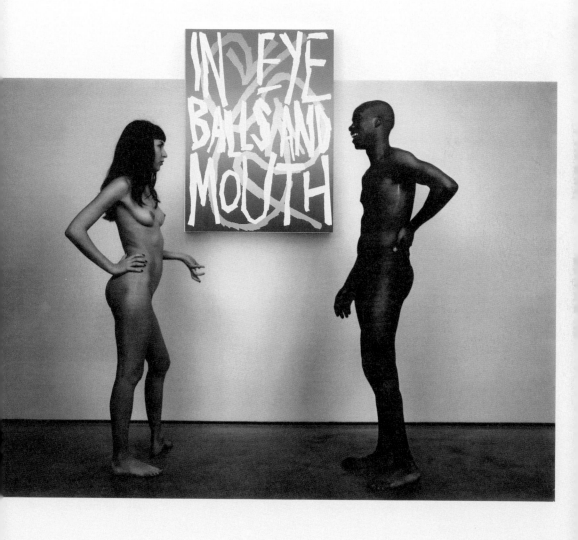

'I love the sheer incongruity of it'
Eddie Peake in conversation with Alona Pardo

AP Your work is firmly rooted in the language of painting and sculpture. How did performance enter your artistic vocabulary?

EP I would venture to say that even before I was making performances my work was performative; it's my feeling that a painting *performs*. I've always liked the idea that an artwork switches on as soon as a viewer enters the gallery. About 15 years ago an ex-girlfriend took me to see a peep show, where you inserted a coin into a slot that triggered a performer to dance for a minute, before vanishing again. In my mind there is an interesting analogy between that experience and the way an artwork operates when a viewer is in front of it.
 A couple of years later, in 2005, I abandoned making paintings exclusively whilst on a student exchange in Jerusalem – my first performance involved walking through the city to the security wall, through Bedouin camps, and I subsequently wrote down that experience.

AP There is a clear political dimension to that first performance that brings to mind the work of

Chris Burden and other male performance artists working in the 1960s and 70s. Is that something that resonated with you at the time?

EP I don't think you can use the body without it being political. It's a very tricky area to navigate when trying to establish some original identity for your own work. When you're working within such a well-trodden ground, every move is a potential minefield of cliché and offensive politics.

 I started to make what I would call 'Performance' after my experience in Jerusalem when I was back at the Slade. Work where there was nothing else involved beyond a live event with people in it – with a beginning, middle, end and an audience.

AP Was performance a part of your life before then?

EP As a teenager I was into drama but at a certain point I became crippled with shyness. Art become a good way of having an exuberant and eccentric offering to the world without it actually being myself on display. When I was at the Slade that extrovert show-off tendency returned and I wanted to be involved in the performance.

 For me, performance induces the most real feelings. I find that when I'm in the presence of someone doing a live performance my emotional response is always very extreme, whether it's

repulsion, awkwardness, embarrassment or some other reaction. I don't tend to respond to art that is a roll call of semiotic codes that tells you that these are the instructions for what you're supposed to think about.

AP You appear in a lot of your early performance work. When did you start collaborating with other people?

EP My second performance, *Fox* (2006), was a collaboration with the artist Sam Hacking. The idea was to set up a rule and have two performers enact it in whatever way they wanted, but the rule would necessarily facilitate a drama. The rule was that two people should swap clothes – one performer wore a fox costume and the other normal clothes – without ever exposing any part of their body, which is of course an impossibility, but the act of endeavouring to do that has its own dramatic narrative. I think of that work as key to everything I've done since, as there was this weird thing about relationships going on but it was also funny, violent, absurd, ridiculous as well as being hypersexual. It was as though one person was emerging from the anonymity of costume, of characterisation, while the other disappeared into it.

AP At what point does the fourth wall come into play?

EP In an art gallery setting there is a certain acceptance of that type of behaviour and the sense of embarrassment quickly dissipates. Doing something ridiculous or parading around in the nude becomes normalised. The gallery is a very interesting location in relation to the question of the fourth wall as – although it inevitably comes down – the audience is not given the luxury of anonymity that they are afforded at a theatre or cinema. The gallery audience has to be active: they have no choice by necessity.

AP The gaze seems to be a constant thread through your work and manifests itself in the reflective mirror paintings through to the apertures in your installations that frame the viewers and performers.

EP Exhibitions like *Adjective Machine Gun* at White Cube in 2013 or *The Forever Loop* in the Curve are carefully constructed so that the installation has specific viewing points and windows through which the viewer sees not only the work but other viewers as framed figures, directly implicating the viewer as part of the show. In a gallery the viewer is on display as much as the artwork, especially in a performance situation, and I like playing with that.

AP Tigers, giraffes, bears and lizards are constant motifs in your videos, performance and sculptures.

I'm intrigued as to what attracts you to the animal kingdom – is it our relationship to wilderness or the animal within?

EP I'm drawn to the metaphoric potential of animals, which is why animal costumes and sculptures regularly appear in my work. When a performer wears a costume, it removes any way of reading the emotional or psychological range at play. The emotion is masked through a comedic and anthropomorphised quality. I'm interested in our innate human impulse to anthropomorphise something that is totally alien to us. For example in *Innocently Wears A Bikini* (2015; p.10, bottom left), making the cut-out acrylic bear wear a shawl imbues it with a distinctly human personality.

AP Your use of nudity and sexual imagery seems to confound and confuse conventional sexual stereotypes.

EP Sexuality and desire are constant themes in my work, but often not the usual imagery you would expect to find filtered through the male gaze.

AP Certainly not a hetereosexual one…

EP I remember reading Judith Butler's *Gender Trouble* (1990), where she paraphrases Simone de Beauvoir

as saying that there are as many sexualities in the world as there are people. I subscribe to that view completely. Imagine what the conversation would be if we didn't have the words gay, straight, bi or trans. I think those terms have been quite unhelpful and actually quite dangerous sometimes. The thing I'm compelled by is imagery and ideas: it's become apparent to me that what I'm interested in is the transcendence of categorised or normative sexuality and, by implication, other things: normative roles in society, race, art.

AP Roller skaters are another recurring motif in your performance work. For me they conjure up images of New York in the 1970s: lurex, spandex and leg warmers. What do they mean to you?

EP Cinema is littered with roller skater references, from Federico Fellini's cult film *Roma* (1972) – where an ecclesiastical fashion show scene is suddenly populated by nuns on roller skates – to Rollergirl in *Boogie Nights* (1997) and post-apocalyptic sci-fi films from the 1990s with bandits on roller blades. I like that my use of them in the gallery context harks back to something completely outdated. I also like the idea of a sculpture that's a human skating through the gallery; it feels like it shouldn't be in that space. I know that it seems a redundant statement because there is really nothing that

shouldn't be in the gallery, but if there is some semblance of that feeling then it excites me.

My work can seem totally incoherent and fragmentary because I want to move in an array of directions through responding intuitively and immediately to all my creative impulses. The roller skater (*The Parkland Walk*, 2015; p.15) operates as an adjoining segue in *The Forever Loop*, connecting everything together. Plus, I love the sheer incongruity of it!

AP Would you say that your work is autobiographical?

EP Yes, unashamedly so. I want the work to feel unequivocally real and so I draw upon real life experiences. The text in the wall painting *Sentence* (2015; pp.8–9) in *The Forever Loop* is loosely related to a time I spent in a psychiatric ward in Camden when I was 20. I tried to commit suicide and I spent the next two months in a psychiatric ward as a result of failing to do so. It was easily, and for totally obvious reasons, the lowest point of my life but it was also a very formative period for my life and work. One little weird memento from that experience, which comes up now and again in my work, is that when I'm in Camden Town I often see an old lady with a shaved head who was in the hospital with me at the time.

41

AP You often bring the language of the street into your paintings, which are emblazoned with colloquialisms and sexuality.

EP It's against my better judgement to use language so emphatically in my work as I find it so clumsy in terms of trying to articulate certain feelings. It's very difficult to translate abstract thought into language, but I'm obsessed with language's faultiness at articulating phenomena that are not inherently language-based, such as emotions, imagery, space and movement.

AP The language in works like *Ejaculate, The Noun* (2015) can be provocative, even confrontational…

EP There is a politics to the colloquial, localised street language. I was born and raised in Finsbury Park where as a white person I wasn't particularly in the majority. I'm aware, of course, that as a white person in Britain I am in the majority full stop. But, in terms of walking around the street, it was very diverse with people of all ethnic and social backgrounds. Through my involvement in academia and the art world I feel that diversity has been filtered out. Using colloquial slang feels like a lamenting of the filtering out of that diversity in my life, so I use a lot of phrases and expressions that I either heard or used as

a kid or teenager, which can seem provocative in that new context.

AP The mirror works especially seem to revel in the freedom and excesses of youth.

P Yes, I spent my teenage years going to jungle raves and a lot of the expressions are literally things that the MCs would say, notably 'shout-outs' to me and my friends. It's quite an aggressive and direct address to the audience. In my work, it's about using that to make something that impacts the viewer and literally grab them. I also like the physical potential of words; the wall painting in *The Forever Loop*, for me, has a sculptural quality because it becomes so physical. The words appear there because they are *not* there; it's a process of negative space-making.

AP Literally like form emerging out of a slab of marble.

P Absolutely. I have to say I really enjoy the act of making the mirror paintings, which mimics the alchemical process in a darkroom. When you see an image emerging, it's a magical moment. I have that same feeling when I apply spray paint to a surface and then peel off the masking tape – the mess suddenly springs to life.

List of Works

Published in 2015
by Ridinghouse and Barbican

on the occasion of
Eddie Peake: The Forever Loop
9 October 2015 – 10 January 2016

The Curve
Barbican Centre
Silk Street
London EC2Y 8DS
United Kingdom
barbican.org.uk

Head of Visual Arts: Jane Alison
Curator: Alona Pardo
Exhibition Assistant: Mairia Evripidou

Ridinghouse
46 Lexington Street
London W1F 0LP
United Kingdom
ridinghouse.co.uk

Publisher: Doro Globus
Publishing Manager: Louisa Green
Publishing Associate: Daniel Griffiths
Publishing Assistant: Jay Drinkall

Distributed in the UK and Europe by
Cornerhouse Publications
HOME
2 Tony Wilson Place
Manchester M15 4FN
United Kingdom
cornerhousepublications.org

Distributed in the US by
RAM Publications + Distribution, Inc.
2525 Michigan Avenue, Building A2
Santa Monica CA 90404
United States
rampub.com

Images © Eddie Peake, courtesy
the artist unless noted otherwise
Text © Omar Kholeif
Interview © Alona Pardo, Eddie Peake
Official copyright for the book © 2015
Barbican Centre, City of London

Copyedited by Melissa Larner
Proofread by Eileen Daly
Designed by Zak Group
Set in Folio BT
Printed in Belgium by Graphius /
Deckers & Snoeck

ISBN 978 1 909932 16 6

British Library Cataloguing-in-Publicatio
Data: A full catalogue record of this
book is available from the British Libra

Great care has been taken to identify
all image copyright holders correctly.
In cases of errors or omissions please
contact the publishers so that we can
make corrections in future editions.

cknowledgements

pecial thanks to Eddie Peake, as well
s Corinne Bannister, Serena Basso,
ene Bradbury, Phil Brown and
PS, Mark Chapman, Laura Chiari,
elen Coultish, Sean Cunningham,
Irika Danielsson, Will Davis, Lynne
ent, Camilla Donghi, Teo Furtado,
usanna Greeves, Celia Hempton,
ay Jopling, Zak Kyes, Dan Lambert,
oyce Lau, Tatjana LeBoff, Jon Lowe,
ine McGuiness, Tim Meaker,
Ionika Nef, Lorcan O'Neill, Georgia
ewton, Lewis Peake, Prem Sahib,
arsten Schubert, Eleanor Spalding,
ino Taranto and Karly Wildenhaus.

erformers: Marina Capasso, Emma
sher, Neus Gil Cortés, Hannah Louie,
anessa Michielon, Gareth Mole,
Iaddy Morgan, Rebecca Namgauds,
laudia Palazzo, Paolo Rosini and
essica Taylor.

oller skaters: Jessica Ashby, Laura
ork, Fattima Mahdi, Sebastian Sandhir,
hyannon Styles and Simone Wells.

Author Biographies

Omar Kholeif is a curator, writer and
editor. He is Curator at Whitechapel
Gallery, London; Senior Visiting
Curator at Cornerhouse and HOME,
Manchester; and Senior Editor at Ibraaz.
As of November 2015, he will be the
Manilow Senior Curator at the Museum
of Contemporary Art Chicago and
a faculty member at the University of
Chicago. The author of numerous publi-
cations, he also writes widely for *The
Guardian*, *Art Monthly*, *Wired*, *Mousse*,
frieze and *Artforum International*.

Alona Pardo is Curator at Barbican
Art Gallery, London. She has worked
on a number of critically acclaimed
exhibitions and publications including
*Constructing Worlds: Photography
and Architecture in the Modern Age*
(2014) and commissions including
Roman Signer: Slow Movement (2014);
Leandro Erlich: Dalston House (2013);
and *Damián Ortega: The Independent*
(2010), amongst others.

arbican

idinghouse

CITY
OF
ONDON

The City of London
Corporation is the founder
and principal funder
of the Barbican Centre

COUNCIL
GLAND

Supported using public funding by

**ARTS COUNCIL
ENGLAND**

he Henry Moore
oundation